The Wee Book of
GLASGOW

Robert Jeffrey

Black & White Publishing

Also by Robert Jeffrey:
Gangland Glasgow
Glasgow's Hard Men
The Wee Book of the Clyde

With Ian Watson:
Images of Glasgow
Scotland's Sporting Heroes
The Herald Book of the Clyde
Doon the Watter
Clydeside – Faces and Places

First published 2003
by Black & White Publishing Ltd
99 Giles Street, Edinburgh EH6 6BZ

ISBN 1 902927 65 6

Printed and bound by Mondragon

INTRODUCTION

The cover photograph for this little book captures something of the essence of Glasgow – a well-developed sense of fun. Many a Glaswegian would fail to recognise the equestrian statue of the Duke of Wellington in Exchange Square without a traffic cone for a hat. And since the statue stands proudly in front of one of the most prestigious new extensions to Glasgow life, the Gallery of Modern Art, it is particularly apt, adding an idiosyncratic exclamation mark to an old, classical work of art. No sooner do the authorities remove the traffic cone than a new one appears. Normally perched at a rakish angle, it has become part of the Glasgow scene. Maybe this passion for participating in art is a symptom of the Glasgow renaissance, the flourishing of pavement café culture, museums, galleries, drama and music that has seen the image of the old city on the banks of the Clyde change so dramatically over these past twenty years or so.

This collection of photographs, mostly culled from the massive picture archive of the *Herald* newspaper, looks beyond the years of the Burrell Collection, the Garden Festival and the City of Culture and all the changes they wrought, to a wider view of the city – a place where work tended to be the hard physical labour of shipyard or engineering workshop; a place where folk found friendliness, and often much happiness, in family life in the unpromising confines of the old tenements; a place where a night at the 'jigging' was more likely than a night at the opera. A place very different from the modern city. Here are backcourt concerts, trams lumbering out of the fog, snow dusting the powerful landmark buildings and sculptures, flashbacks to the great comedians and sporting idols, streets of stone darkened by the grime of industry – together a tribute to a place that has reinvented itself as one of Europe's great cities.

Robert Jeffrey
Carradale, January 2003

In recent years Glasgow has transformed its image in dramatic fashion. The closure of some of the world's greatest shipyards and the decline in heavy industry hit the city hard. But an energetic series of counter-offensives in the closing years of the twentieth century created something of a renaissance, and now the city has a world-wide reputation for adventurous music, drama and architecture. Its museums and parks match the best in Europe. Anyone with a thirst for shopping finds Glasgow an ideal place for pleasurable retail refreshment.

This is Princes Square, just off the pedestrianised Buchanan Street, not long after the glitzy shopping complex opened. It is 1994 and a fashion show attracts an appreciative audience amid the up-market shops, restaurants and even stylish barrows selling novelty goods. This is the style of the new Glasgow experience.

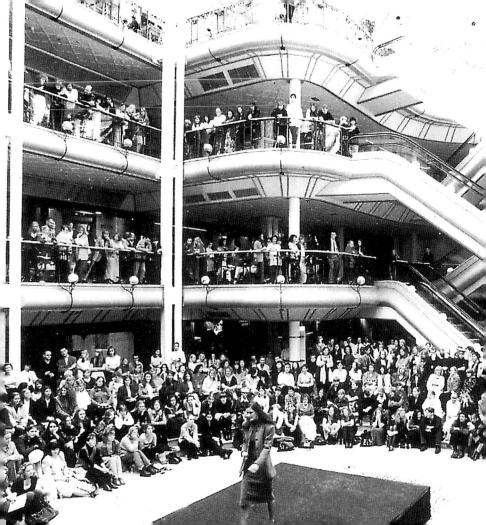

Glasgow was always a great place for book browsers (and readers). Even after the Second World War many of the city centre lanes were home to book barrows and barrow boys with an intellectual touch, who found no shortage of buyers for their wares. And everyone seemed to have their favourite bookshop in the days before international chains dominated the market. John Smith in St Vincent Street, Porteous in Exchange Square and, perhaps most famous of all, the Grant Educational Co. in Union Street are all gone but their memory lingers on. Right beside the Central Station and in the good old days of steam, the station tearoom, Grants, was on a prime site and well stocked with helpful staff as interested in the books as the customer. It is sadly missed. In this shot from the early 1930s it advertises its quaintly named Glasgow Book & Bible Saloon.

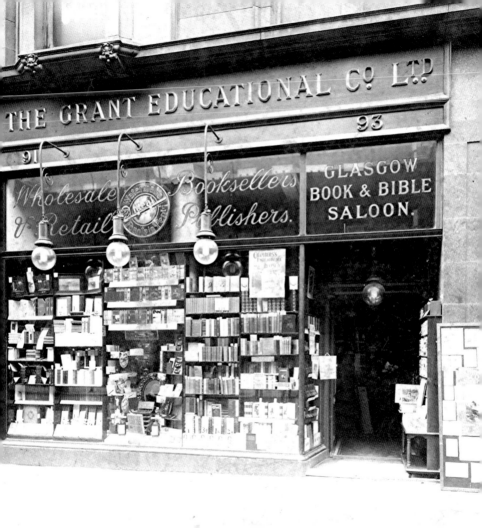

Buchanan Street may have had to wait for almost a hundred years for Princes Square, but even at the turn of the century it was a shopping Mecca. H. Samuel at the junction with Argyle Street has supplied engagement and wedding rings, alarm clocks and watches to thousands of Glaswegians down the years. Latterly, the clients arrived by car, bus or tram, but here the main mode of transport is genuine horsepower. Milk churns, barrels and sacks of grocery items crowd the foreground. And, as a reminder that just maybe the weather really was sunnier in the good old days, almost all the shops feature blinds to protect the shopper – and the merchandise behind the plate glass – from the blazing sun. In the modern era Fraser's department store operates behind the still imposing stone facade.

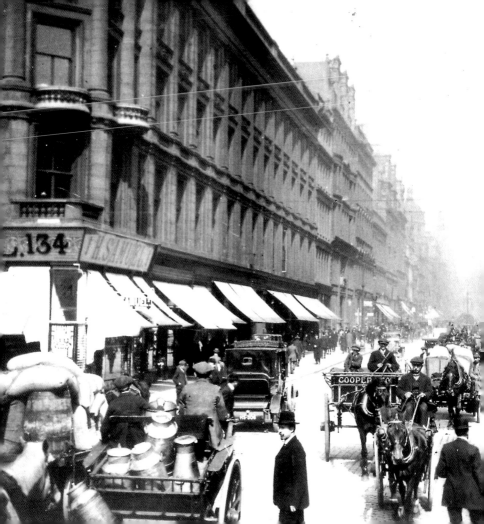

Rain glistens on the polished cobblestones and the wet tram rails are ready to push an unwary cyclist or car driver into a spin. This is an evocative night scene of Renfield Street viewed from the junction with St Vincent Street. The Barr's Irn-Bru neon advert, shining down through the familiar drizzle, was much loved by the locals who do, it has to be said, retain a remarkable capacity to drink the stuff – especially as a restorative after a night on the town downing liquor of a somewhat stronger nature!

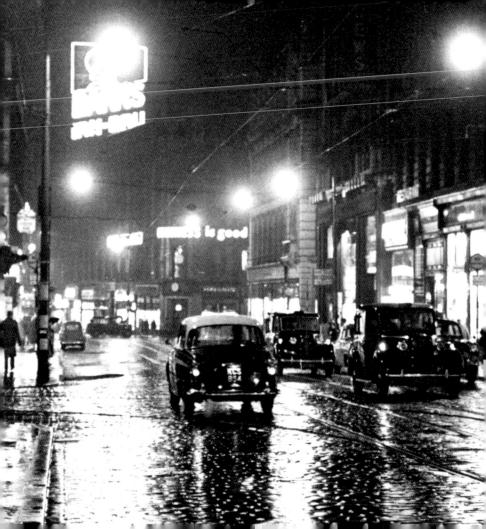

If half a century ago the summer sun shone more brightly, the winter snow was also more of a problem than in recent years. A covering of the white stuff always made the city's bold architecture, darkened by the smoke and smog of the coal fire era, more attractive to look at, but it wasn't much fun for a carter or his horse. Or, indeed, for the driver of an underpowered electric milk float. But the many statues of George Square undeniably acquire a little extra nobility in the snow.

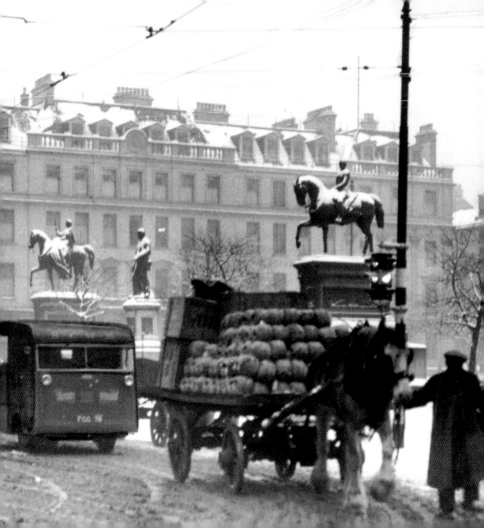

A favourite weekend excursion for Glasgow families down the years has been a visit to Provand's Lordship, the oldest building still standing in the city. Just across the road from the Cathedral, the exterior is not particularly striking, but inside the feeling of history is strong. Built around 1471, it had fallen into some disrepair but was refurbished comprehensively in the 1990s. This is how it looked in the mid-'50s. There's a real Glasgow touch in the wifie in a headscarf pulling a steamie load of washing on a bogie.

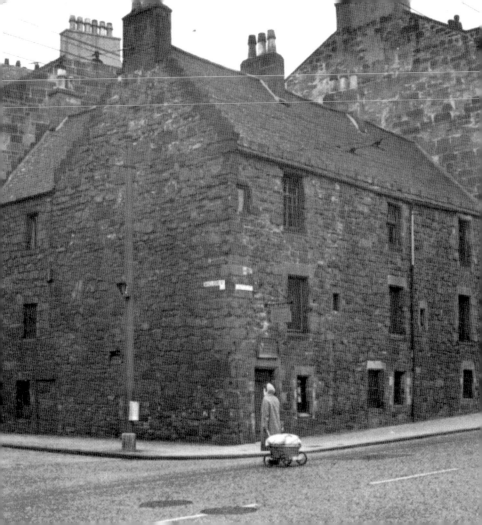

Social life was changing fast in the 1950s. Famous grocers like Massey's and Lipton's were soon to be under threat from multi-national chains and cash-and-carry warehouses. Another Glasgow institution, the mid-morning coffee break, was also dying out. In these more leisurely days, office work stopped at eleven for coffee – not 'dishwater' spewed out of a drinks dispenser, but a fresh brew poured by a waitress into a china cup at an establishment a stroll round the corner from the office. This vanished way of life is caught in Craig's smoke room and picture gallery in the basement of the old Gordon Street restaurant, as it was on its last day of business, Saturday, 2 April 1955.

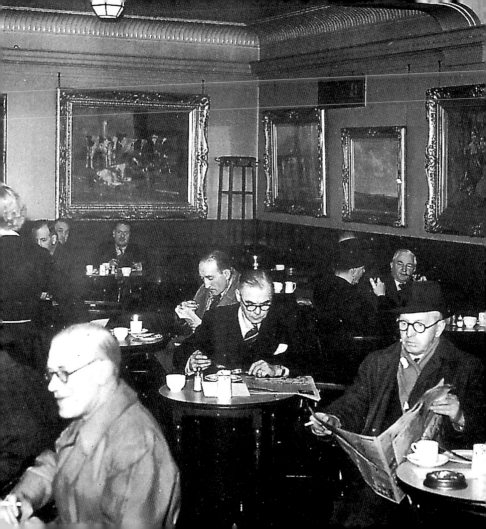

There must be a few far-flung corners of the globe where they have never heard of Sauchiehall Street, but I have yet to find one! This is a classic 1950s scene of one of the world's most famous streets looking west to Charing Cross. In the distance is the imposing façade of the Grand Hotel which was demolished in 1969 to make way for the motorway approaches to the Kingston Bridge. In the foreground is the striking art deco style Beresford Hotel whose incongruous yellow tiling is a local landmark. After its days as a hotel were over the Beresford became student accommodation.

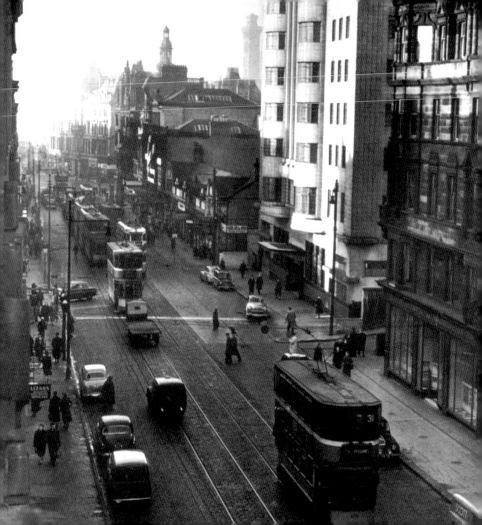

In the 1950s Glasgow was said to be 'dancing daft'. And the city had a vast number of dance-halls, small and large. Establishments like the Locarno, the Majestic, Barrowland, the Albert, the Plaza and Dennistoun Palais de Danse were thronged night after night with couples escaping from drab suburban semis or tiny flats in featureless housing schemes to dance to the exciting throb of a big band. This was the world of the foxtrot and the tango, shoes that shone well enough to see your face in and dresses rich in spangles and sequins. This image, shot at Dennistoun, captures the feeling of a winter night at the dancing.

Barrowland was a particular favourite, a great place for a glamorous night out with a good chance of a pick-up. Thousands of Glasgow marriages began with a swing round the polished floor of the ballroom built above the famous barrows market. This is Hogmanay 1982 and the aficionados are enjoying the music of George McGowan and his band, themselves something of a legend on the Glasgow dance-hall scene. As was that other Barrowland band, Billy McGregor and the Gaybirds, a name that makes its own comment on a less complicated era. Latterly, Barrowland has hosted gigs by some of the world's top rock acts – including David Bowie and U2 – and is still a popular music venue.

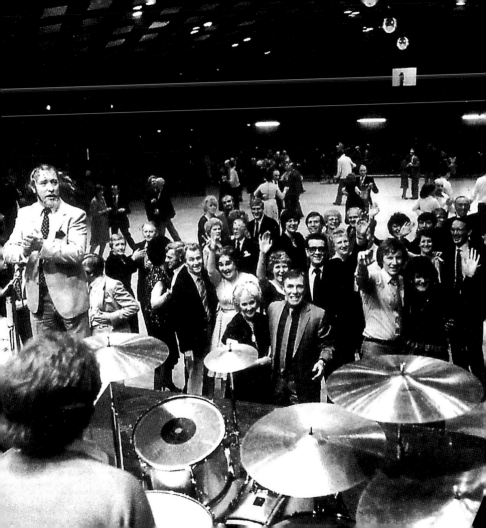

Backcourt concerts were a Glasgow institution and Alex Harvey (who liked to be billed as, the Sensational Alex Harvey) was said to have taken part in this one in Thistle Street in the Gorbals. The object was to raise cash for old folk and the main attraction was the Kinning Park Ramblers who used the back of a lorry as a stage. Some locals crushed into spaces between wash-houses and coal cellars, and others resorted to the time-honoured Glasgow passion for 'windae hingin'. A pipe band also featured and the entertainment was a mixed bag of rock 'n' roll, Highland dancing and comedy skits.

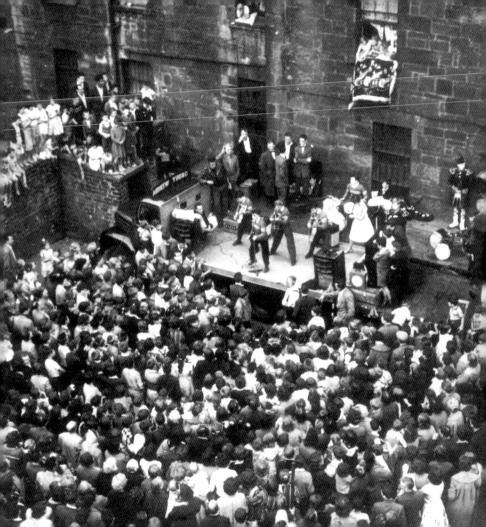

Glasgow folk are still great theatregoers but the television era swept away some of the best known venues . . . the Alhambra, the Empire (graveyard of many an English stand-up comic) and the Metropole (home to the Logan family). The King's remains a favourite for spectacular pantos and hosts touring shows and the big amateur-drama clubs' winter shows. The audiences arrive these days in cars a little more sophisticated than this Wolseley which appeared on stage in a show called Out to Win *in the 1920s. The façade is much altered, but inside this magnificent old theatre looks much as it must have done in its heyday.*

The cinema also drew huge crowds of Glaswegians for nights out in the city centre. A favourite was Green's Playhouse which was once billed as 'Europe's largest cinema'. It changed with the times to become the Apollo, a concert venue that played host to some of the world's biggest stars and groups. This is 1975 and that home-grown talent, Billy Connolly, looms larger than life over Renfield Street. The Apollo is now gone but Renfield Street still boasts the much-loved Pavilion Theatre, once home to entertainers such as Lex McLean, Glen Daly and Tommy Morgan.

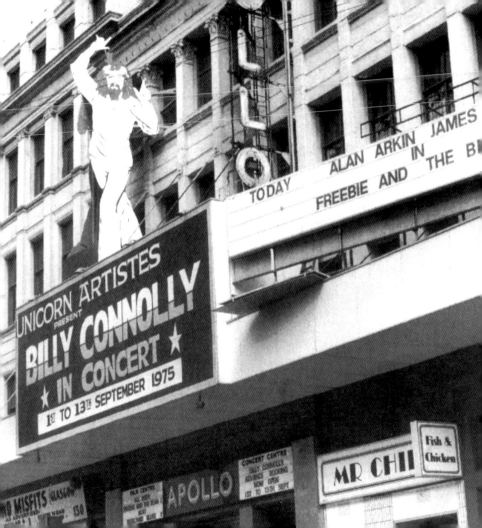

In recent years Glasgow has paid much attention to its heritage which has paid off in a growing trade in tourism. One of the major new attractions is the St Mungo Museum of Religion built in the precincts of the Cathedral, which is itself a major draw. The whole area has been cleverly re-landscaped and, with the nearby Provand's Lordship, it has become a must-see for visitors who can stroll up from George Square to High Street and spend an hour or two in one of the oldest areas of the city. This how the Museum of Religion looked in 1993 shortly after it was completed. Since then, the gleaming new stonework has darkened down, but this has helped it merge successfully with its ancient neighbours.

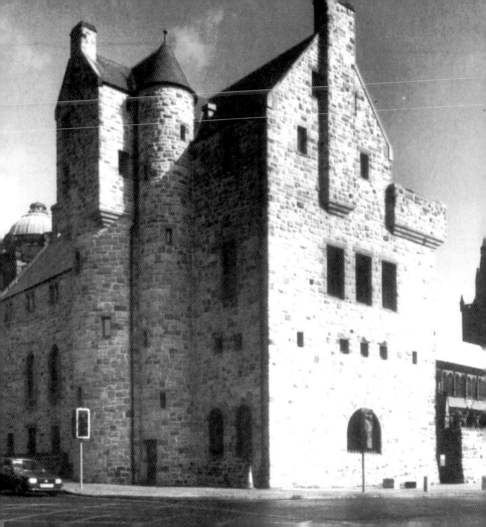

The work of Glasgow's internationally renowned architect Charles Rennie Mackintosh is another major draw for tourists. And the city knows it well. The House for an Art Lover in Bellahouston Park is a model of how to make use of heritage. But fans of Toshie will also make for the acclaimed School of Art, just off Sauchiehall Street, acknowledged worldwide as a successful blend of arts and crafts and Art Nouveau ideals built between 1898 and 1906. This floodlit scene on the other side of the Clyde shows what was a working school but is now Scotland Street School Museum. Built a few years later than the art school, it is a must-see for those interested in education and is a well-preserved example of the master's work.

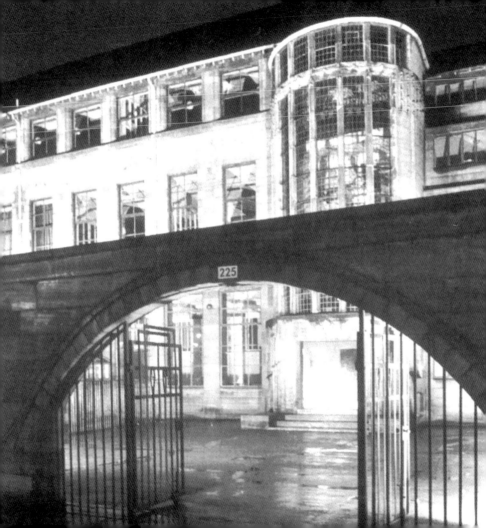

Perhaps the two best known liners in maritime history, the Queen Mary *and the* Queen Elizabeth *were both born on Clydeside, as was the legendary QE2, seen here under construction at John Brown's yard in 1967 and, inset, as she looked on completion. In 2003 the QE2 is on a final farewell tour of the world's great harbours before being taken out of commission to be replaced by a new super liner, the* Queen Mary 2, *nearing completion in France. One can imagine the clang of the steel plates in the remaining Clyde yards being drowned out by the sound of thousands of old-time Clyde welders, plumbers, platers and shipwrights turning in their graves.*

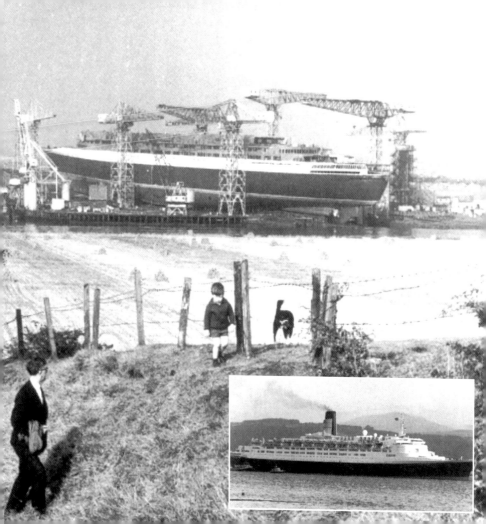

The Clyde and its many bridges are a magnet for photographers. This unusual shot was taken from a high-rise flat on the southside in the early 1990s. The sailing vessel Carrick, *formerly the* City of Adelaide, *is moored at Clyde Street, and in the foreground, the new Sheriff Court is under construction and the city mosque is on the right. The* Carrick *was moved to the Scottish Maritime Museum in 1992 but funding problems have delayed restoration of this fine ship, which in its days in central Glasgow was used as a meeting place for, among others, the Cape Horners' Club.*

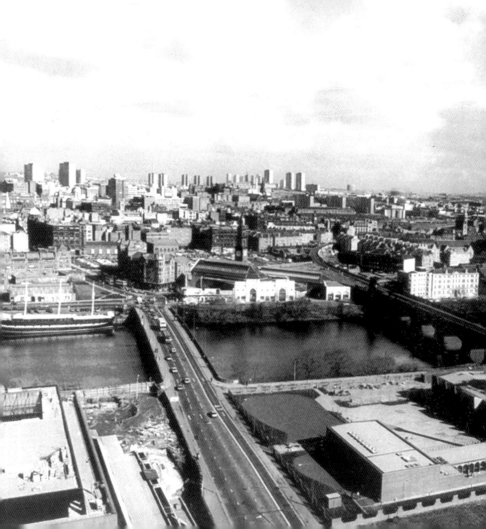

For every Glaswegian who has used it the most memorable feature of the city's tiny underground system would perhaps be the distinctive smell of stale air wafting up the stairs from the stations – something that the camera can't capture. Nonetheless this shot evokes much of the atmosphere of the old underground before it was revamped and new rolling stock, painted bright orange, introduced. It is no surprise that the Glaswegian talent for nicknames meant that from day one of the new rolling stock the old subway, with its city centre circular route, was known affectionately as the Clockwork Orange. Typically of the good old days, there is not a 'No Smoking' sign in sight.

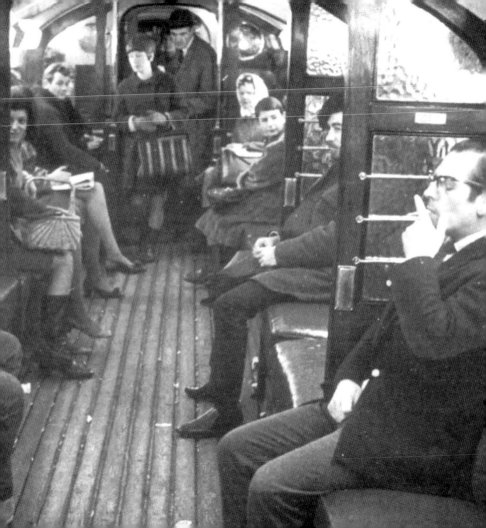

A lasting memory for many a Glaswegian was a Sunday afternoon visit to the Art Galleries at Kelvingrove. The smell of polish on the shiny wooden floors and the respectful silence as good Glasgow folk savoured the great works of art made almost as much an impact on young minds as the exhibits. Behind the daunting, impressive entrance, all dark wood, thick glass and polished brass, lay an exciting world to explore. Everything from a stuffed elephant and spears and weapons brought back from Africa to massive working models of the engines that powered ships built just down the road in the yards. And, of course the chance to see the work of some of the world's greatest sculptors and painters, including Dali's Christ of St John of the Cross, *bought for the city by the legendary Tom Honeyman. Just across the road is the Kelvin Hall, for years home to the Christmas circus and carnival. These two landmark buildings must have had a greater effect on young lives than perhaps any others in the city. And both still spin their magic to this day.*

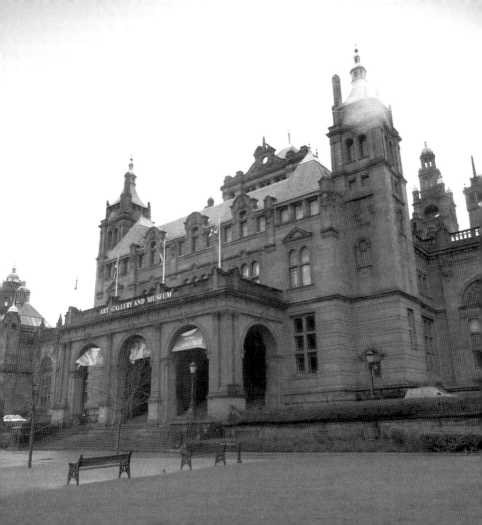

The Herald newspaper has one of the largest picture archives in Europe, running into many millions of historic images. One of the most famous, and most published, is this remarkable photograph of the Red Flag being raised in George Square on 27 January 1919. This event took place during the so-called '40 Hours Strike' and the demonstration was addressed by, among others, Harry Hopkins, Manny Shinwell and Willie Gallagher. The police stood aside on this occasion and eventually the crowd dispersed peacefully. But just a few days later there were clashes between the strikers and police and the army was brought in to help restore order.

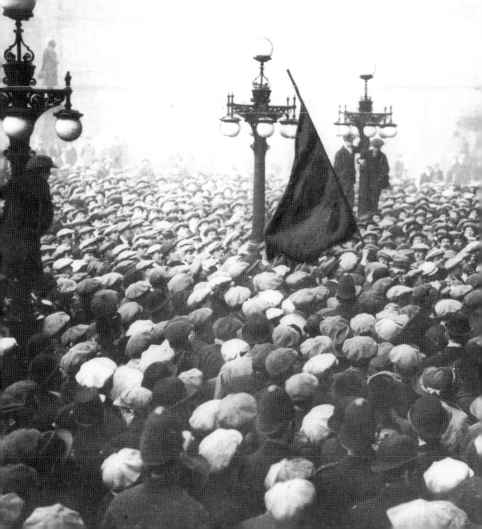

Another evocative image from the days of the Red Clydesiders. At one of the rallies during the 40 Hours Strike the Riot Act was read and troops and tanks, not long finished with the Great War, were called in by the Government. Here the crowds are out in force – almost to a man wearing the regulation flat caps of the era – to watch the progress of the soldiers. Squaddies slept on the floor of the City Chambers and the then Secretary of State for Scotland, Robert Munro, is reported to have claimed that the demonstrations and rallies were not a strike but a 'Bolshevist uprising'! It took years to restore industrial peace and, in 1926 – seven years after the 40 Hours Strike – a general strike lasted nine days, although the miners, as ever in the forefront the industrial struggle, stayed out for nearly six months.

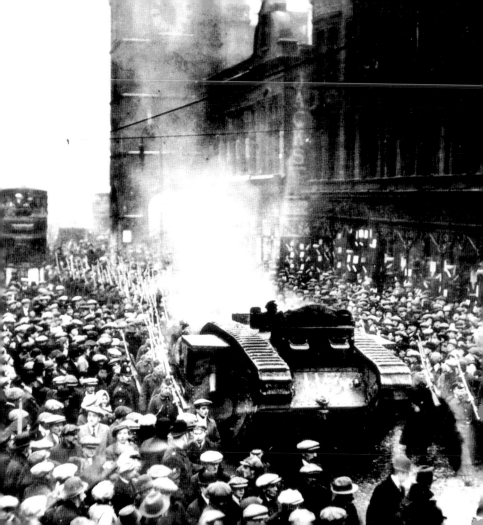

Glasgow was known around the world for building the finest locomotives and ships. The railways of Egypt and India in particular owe a debt to the skill of Scottish engineers. Here a pair of steam traction-engines and a locomotive bound for the docks and export leave the North British Locomotive Company's works in Springburn. In the 12 months from 1947, the NBL built the remarkable total of 32 of these locomotives. But the days of steam were already numbered and the famous firm went into receivership in 1962. Ironically, the engines they built would continue hard at work in far-flung corners of the old British Empire for years after the demise of the factory.

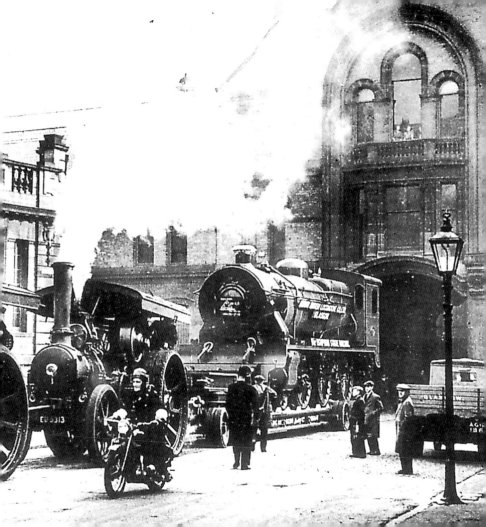

The Waverley *is a much photographed Glasgow icon, the world's last sea-going paddler and a living reminder of the great days of holidays 'doon the watter'. This is not the usual picture postcard shot of the famous vessel. Here, in early 1976, she is being towed down a busy river from Anderston Quay to the old Stephen's dry dock at Govan where she was to have repairs to her boilers.*

The cranes of General Terminus Quay, long blasted away by the demolishers, tower over the south bank of the river on what was to become the site of the Garden Festival. There was good news for the many fans of this lovely old vessel in early 2003 when it was announced that money had been found for much needed and expensive repairs designed to keep the Waverley *in action in British waters for years to come.*

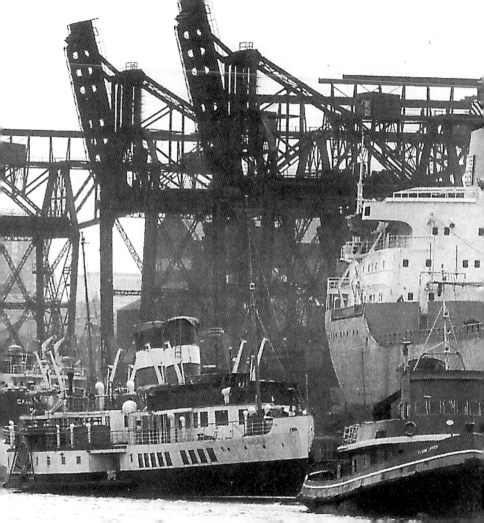

A scene in remarkable contrast with the heavy industry of the yards and railway workshops. This is a farm in Soho Street near Gallowgate in the 1930s. Surprisingly, one or two farmsteads survived close to the centre of the city long after most of the fields had given way to tenements. Geese, sheep and a donkey make the most of their urban surroundings. One famous farm that survived for years in the Tollcross area was called Egypt – simply because the owner had served there in the army.

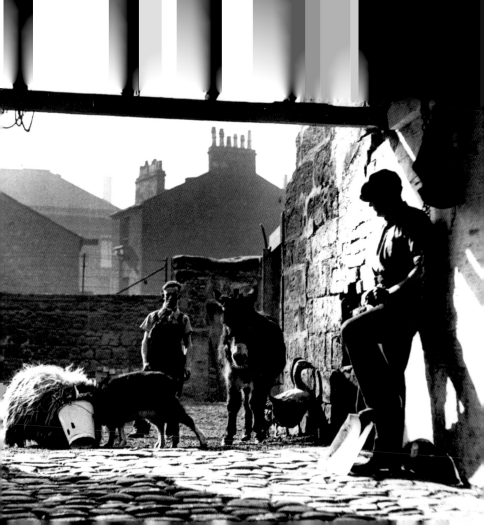

Paddy's Market is an open-air institution that is still in operation to this day. It began in the 1820s and has had various sites round Shipbank Lane, on the north bank of the Clyde near High Street, taking its name from the fact that this was an area where Irish immigrants to the city gathered to sell cast-off clothing. Nowadays more than clothing changes hands – furniture, old fridges and all sorts of bric-a-brac are on offer. And much bargaining is done by customers seeking value for money – something of an enduring Glasgow trait.

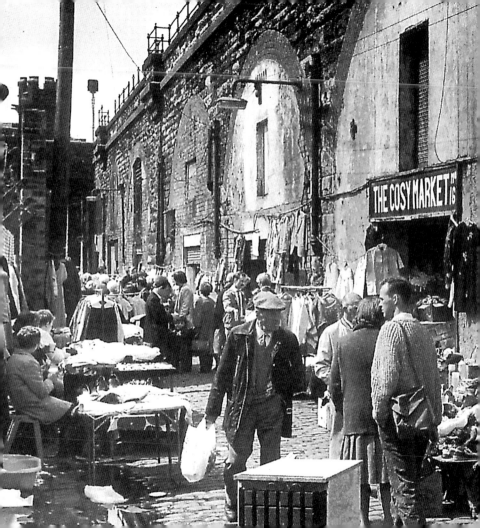

Glasgow's other famous open-air market is the Barras in the Gallowgate area. Much more organised than Paddy's Market, it is particularly busy around Christmas. This is the 1950s, and dolls and teddy-bears are hawked with intensity and gallus style. The patter of the stall-holders is legendary. And the Barras has moved with the times, with trendy, wrought-iron gates, and computer games and software galore on sale – as well as the old staples of carpets, wallpaper, furniture and the like. Although the buskers and street performance acts like that of Ivan Orloff – a well remembered ex-Russian army officer, whose strong man act always drew a crowd – are not seen in the same numbers in these more sophisticated days, the draw of a browse in the Barras is still as strong as ever.

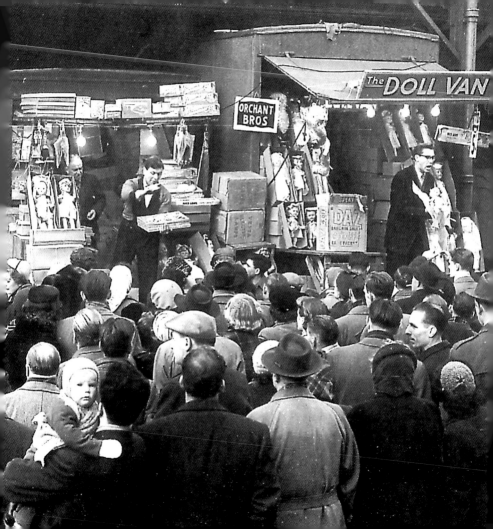

It looks like a scene from a Hitchcock thriller, but it's simply one of the many pedestrian ferries that criss-crossed the Clyde before the tunnel and the Kingston Bridge stole the traffic. This was the crossing at Whiteinch on a bleak December night in 1963. The pedestrian ferries were vital in the heyday of shipbuilding, transporting workers to and fro across the river as both banks were crowded with yards employing thousands who did not necessarily live on the right side of the water for access to their work.

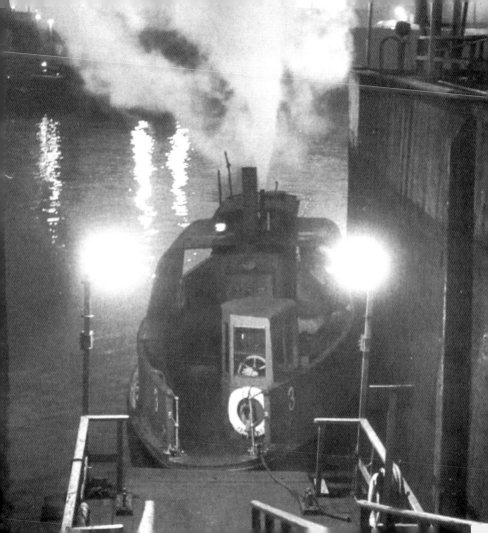

Glasgow's old and elegant bridges were and still are busy places, despite the construction of the Kingston Bridge and then the motorway system in the 1970s. This is Jamaica Bridge, thick with traffic heading into town and with the stylish architecture of Carlton Place in the background. Single-decker buses, double-deckers, lorries and cars are there . . . but the trams dominate, showing just how much Glaswegians depended on them to get about. Here is a good mixture of the old 'shooglies' and the more modern Coronation trams. In their heyday, you could ride the iron rails from towns as far apart as Paisley and Airdrie, with hundreds of stops in between.

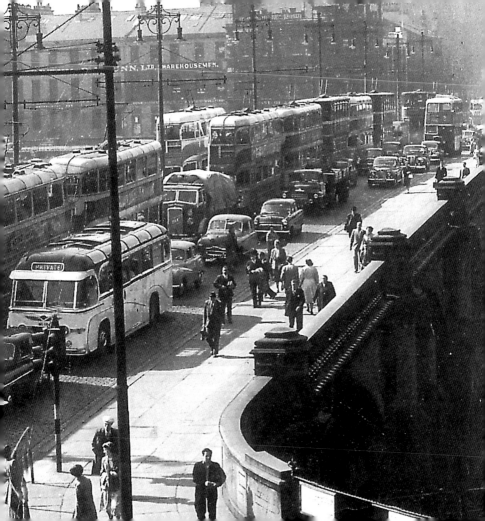

Glasgow's impressive industrial landscape has largely disappeared under modernisation, but some unforgettable sights remain. Like the massive Finnieston crane, whose tremendous lifting power ensured that it survived in working order long after its neighbours had been dismantled and the steel melted down. Its appeal as an icon of the great days has long been recognised and often used in spectacular fashion, floodlit here at Christmas in the 1980s. And who can forget sculptor George Wylie's idiosyncratic creation, a giant straw locomotive hanging from its jib which was then deliberately set ablaze to symbolise the passing of Glasgow's industrial age?

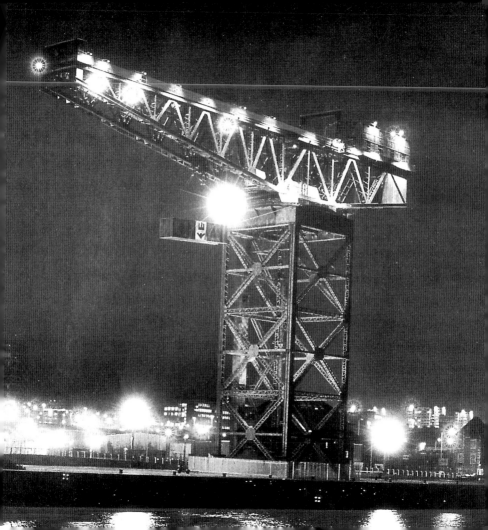

Finnieston had its ferry as well as that famous crane. Vehicular Ferry Number 3 was the less than romantic designation of this curious vessel making its way, heavily laden, across a busy river. It was snapped here framed between the stern of a huge freighter and a dredger. Dredgers were a familiar sight in the days when traffic on the river was heavy and large ships made their way, with the aid of tugs, almost into the heart of the city. Many an office worker spent his lunch-times munching a sandwich and watching the dredgers at work, giant buckets of mud being swept high on huge chains from the river's bottom and dumped into their holds ready to be taken down river.

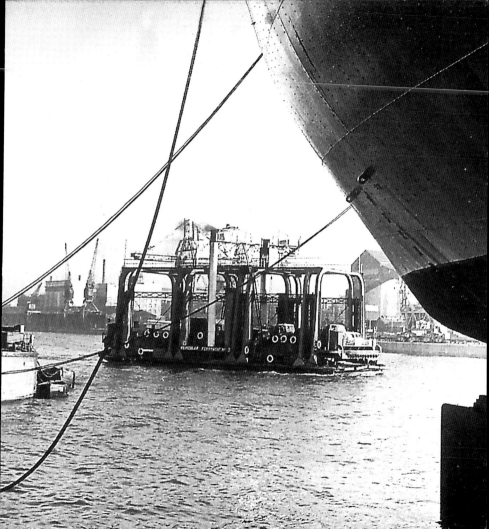

The 1988 Garden Festival was a major turning-point in the renaissance of the city. The opening day was an unforgettable Glasgow experience. Here Princess Diana, Prince Charles and Scottish Secretary Malcolm Rifkind share the top deck of an old city tram, while crowds thronged the festival site and boats were thick on the river. The Festival was a successful trigger for the regeneration of the city centre, and the lustre it added was further burnished by the decisions to award the city the designation European City of Culture in 1990 and UK City of Architecture and Design in 1999.

There are not many Glaswegians without a fond memory of summer days at the festival. Even if some were a little damp.

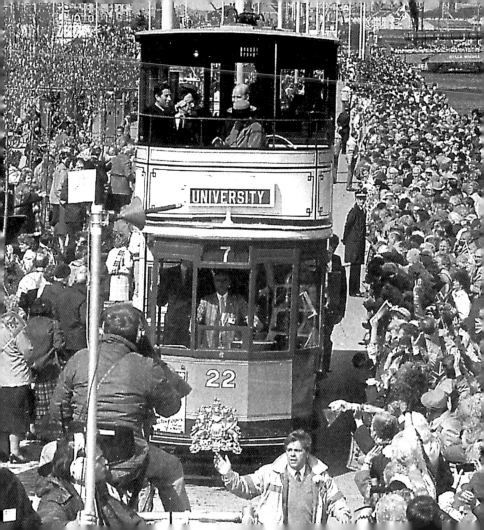

Glasgow had shown a taste for festivals as far back as 1938 when the Empire Exhibition attracted more than 12 million people to Bellahouston Park in the period between Spring and Autumn. On the final night almost 400,000 people endured a downpour to enjoy a poignant and happy evening as the shadow of a world war drew ever closer. The mighty Tait's Tower was a striking spectacle in the night sky. Its Sunday name was the Tower of Empire and it was the work of Thomas Smith Tait, the architect-in-chief of the exhibition. The tower, like the Empire itself, was to pass into history.

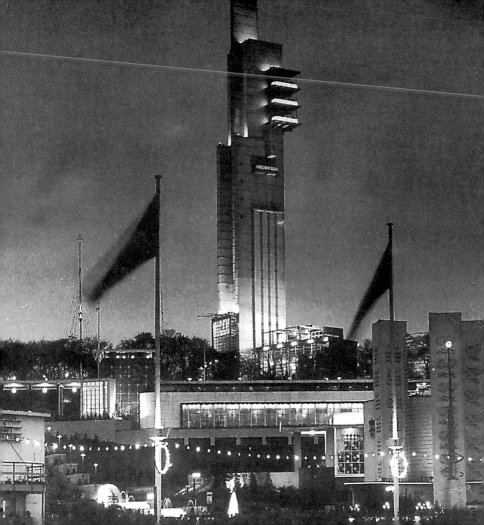

The fighting streak in Glaswegians produced many world famous boxers. A natural successor to Benny Lynch and the much loved Peter Keenan was Jim Watt, who had an astonishing run of five world title wins in Glasgow in venues as different as Ibrox Park and the Kelvin Hall. Here, famous cuts man Dunky Jowett and impresario Jarvis Astaire lead the applause as the boxer celebrates. On retirement Jim, a friendly and humorous man who was an excellent after-dinner speaker, made a new career for himself as a pundit on national TV, with fluent and sensible commentaries and summaries.

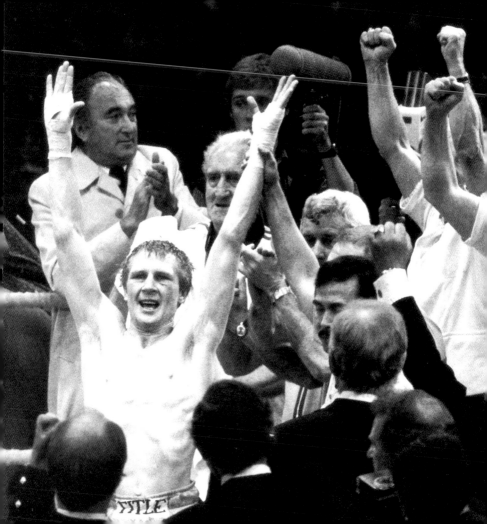

As well as boxers, Glasgow has had many football sporting heroes who have written themselves into the city's folk memory. None more so than the Celtic side of 1967 who became the first British team to win the European Cup, the Lions of Lisbon. Here, skipper Billy McNeill leads his team-mates home in triumph after their momentous win over Inter Milan in the May of that year. The photographer caught Billy and the beribboned cup with Bobby Murdoch, Jimmy Johnstone, John Clark and Bobby Lennox. Billy went on to a career in management that brought success with Celtic and Aberdeen.

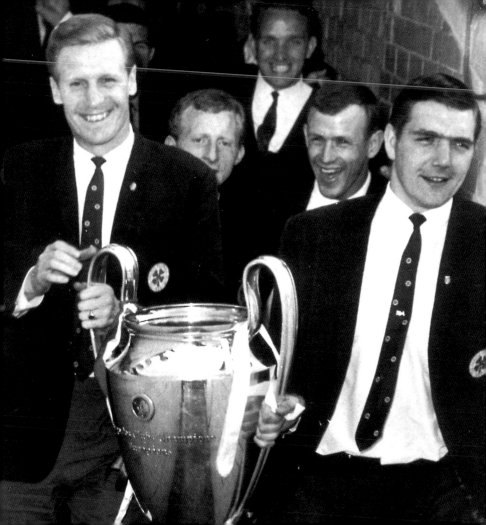

Just five years later Rangers, too, won a major European championship, this time the Cup-Winners Cup in 1972. Skipper John Greig, sporting a swashbuckling look, had Derek Johnstone squeezing in on his right while Tommy McLean, Alex MacDonald and Sandy Jardine are on the skipper's other flank. The Ibrox side beat Moscow Dinamo 3-2 in the final. John Greig went on to manage the club for a spell before taking a backroom post at Ibrox. Sadly for both members of Scotland's Old Firm, success in Europe has been harder to find in recent years, though the optimism that we can beat the world remains

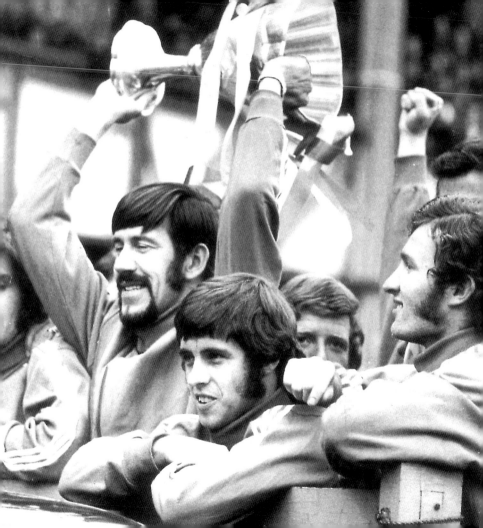

Hampden was once the mightiest stadium in the world, home to boxing, rock concerts and even a religious revival, as well as football's biggest events. Some idea of this awesome place when full is conveyed with this aerial shot of 90,000 people – almost 40,000 less than for the European Cup final! – called to hear Billy Graham preach in April 1955. The world's best-known evangelist was quite a draw. He held several crusades in Glasgow and many of his converts still influence public life. The old football stadium packed to the brim and echoing to hymns and hell-fire preaching was an unforgettable experience. Safety concerns have cut the capacity but rebuilt as the National Stadium, Hampden retains its magic at big events.

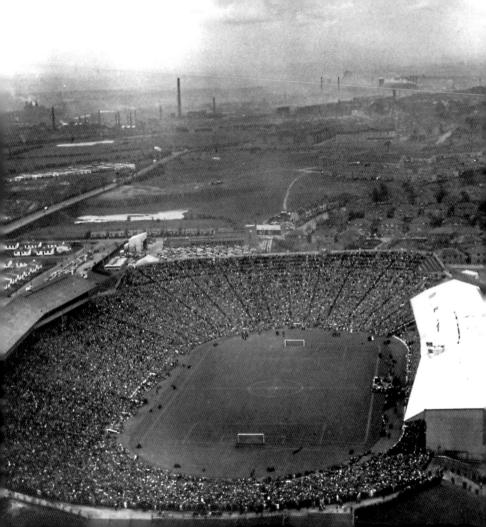

One of the most enduring memories of my boyhood was being taken by my father to see the trace horses in West Nile Street in the 1940s. These magnificent beasts stood in line waiting to be hitched to other horses and carts struggling with the gradient and slippy cobblestones. Once the hill had been climbed, they turned round and returned to their stance beside the pavement where they were patted, and often fed, by the local citizenry who took great pride in this unusual city centre transport operation. The horses themselves seemed to enjoy the work and revelled in the attention of the good folk who often packed a sugar lump in their overcoat pockets.

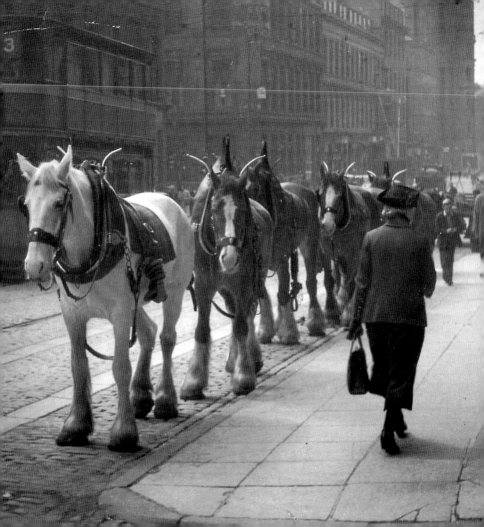

Before the advent of smokeless fuel and the demise of heavy industry, Glasgow suffered severely from smog and fog. I remember having to walk down the tram rails, unable to see the side of the road, in order to find my way home. And cars were often abandoned at the roadside by owners unable to see even a foot or so beyond the bonnet. Set against such fogs, this is merely a gloomy winter's day as the Maryhill tram looms into view at the junction of Argyle Street and Jamaica Street. In fogs, the trams, of course, had a big advantage over other forms of road transport – they just had to stay on the rails.

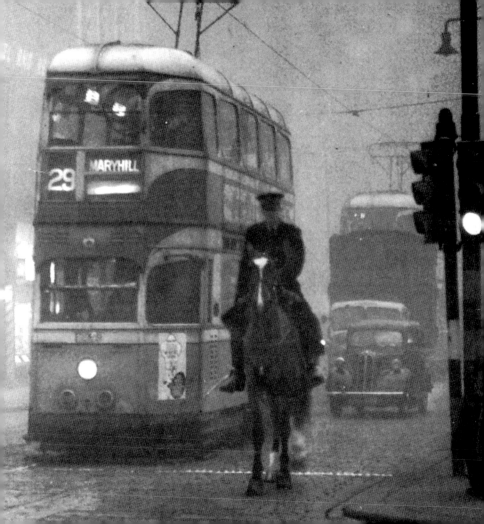

But staying on the rails was not inevitable for the 'caurs'. Generally speaking the tram was a safe method of transport, but accidents did happen, though mostly at slow speeds. This one looks serious, but the caption tells us only that many were injured. The impressive spread of billboards is evocative of the time, and two of Glasgow's passions feature strongly – keeping the house spotless and going to the cinema. Rinso and Vim pitch their wares at the housewife while in the cinemas Gunga Din *and* In Name Only, *both starring Cary Grant, are on release, indicating that the photograph was probably taken in 1939. If you preferred live shows, Rob Wilton topped the bill at the Empire – Glasgow's now demolished but legendary variety theatre.*

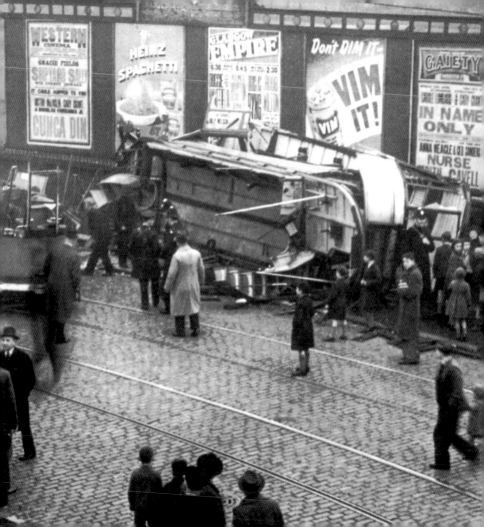

82

A tram adds period flavour to this West End view, taken in the 1930s, at Kelvinside Church and the Botanic Gardens and Great Western Road. The pavements had just been widened and the environmentalists of the day, or perhaps just some sensible councillors, made sure that the trees were retained. Instead of traffic lights a policeman directs the traffic and, as is normal in many of the archive pictures, almost everyone in sight wears a hat.

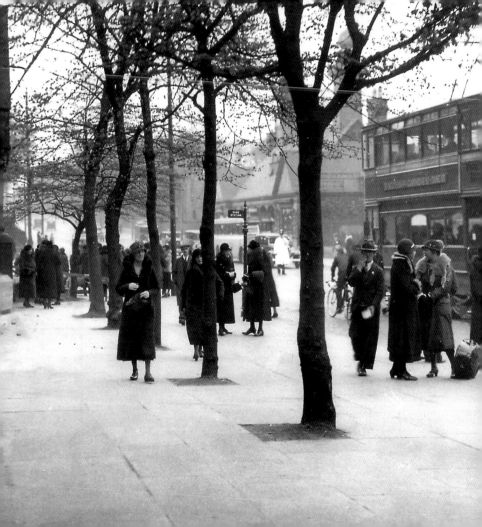

Templeton's old carpet factory in Glasgow Green is one of the city's most remarkable buildings. It was built after the style of the Doge's Palace in Venice because John Templeton believed that factories could be places of beauty – not just for the sake of the workers, but for the sake of the arts generally. In 1889, before completion of the whole structure, a wall collapsed killing 30 women working in the weaving sheds. A second disaster occurred in 1900 when another 70 people were killed in a fire on the site.

Glasgow has its fair share of attention-grabbing buildings. Many are by Charles Rennie Mackintosh, leader of the Glasgow Style which grew out of Art Nouveau, but the city's architects and designers also took to the later Art Deco movement. A classic example of this is the Rogano Restaurant just off Buchanan Street. After a period of decline it was restored in the 1980s to its original 1930s glory. The impressive figure is the famous doorman Alfred Pickles, seen in the mid-'80s. The restaurant is still popular to this day, though the young bucks who used to crowd the bar in cavalry twill and blazers on Friday nights – who became known as the Rogano Light Infantry – are merely a memory.

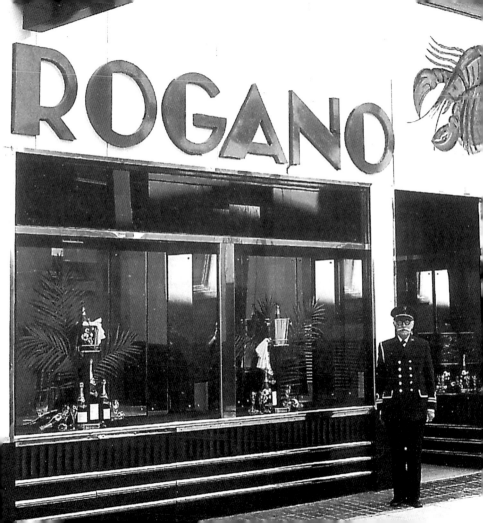

Every Glaswegian has memories of Central Station, starting place for adventures galore, be it the night-sleeper to a new job in London or the train to Gourock for a journey 'doon the watter'. Before the Spanish costas lured holidaymakers to guaranteed sunshine, the annual Fair holidays – last two weeks in July – saw a massive exodus from the Central, with dozens of extra services, and queues winding their way far outside the precincts of the station itself. This is how it looked in the 1950s at the Fair, most of the passengers in this shot heading south from platforms 1 and 2. The Clyde coast resorts were mostly served by platforms on the far side of the station.

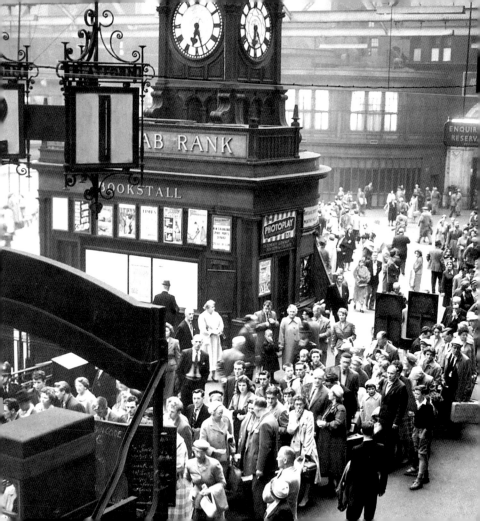

Central Station still serves Glasgow in the days of Virgin trains and the electrification of suburban lines, but the magnificence that was St Enoch Station is no more. It closed in 1966, although the impressive hotel that adjoined it lingered on until 1974, a monument to Victorian marble and mahogany. Where the hotel and station stood is now a modern massive glass-skinned shopping centre, a dramatic city centre landmark very different from the dark and cavernous old station. In 1879 St Enoch was the first public area in the city to be regularly lit by electricity.

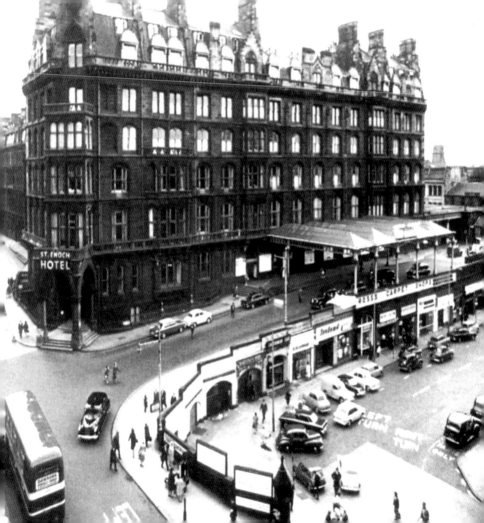

Late at night, with the crowds long gone from George Square, the City Chambers is an impressive floodlit sight. Inside, the ornate interior is no less impressive and has been used in films as a stand-in for the Vatican and the Kremlin. The square itself has seen much history, from the raising of the Red Flag during the industrial troubles of the early part of the last century to visits from Russian leaders. With a hint of irony, the surface was re-laid in red a few years ago, prompting the nickname Red Square. At the heart of Glasgow it is a place to sunbathe in the summer or skate in the winter when a temporary ice rink is erected to create Glasgow's own winter carnival.

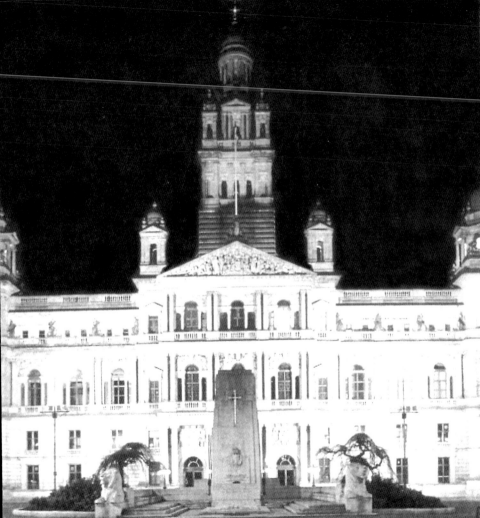

When the Scottish Exhibition and Concert Centre was opened on Clydeside dockland, just down the riverbank from the Finnieston crane, the facilities were much appreciated by the citizenry, but the exterior of the building came in for much criticism. It became dubbed, with some justice, the Big Red Shed. Then, a few years later, along came this new building as a neighbour – a theatre and exhibition space of some style. The wit that christened the Shed this time named the new addition to the city's architectural heritage the Armadillo. It may not have the scale of Sydney Opera House, but this innovative structure is a striking addition to the city.

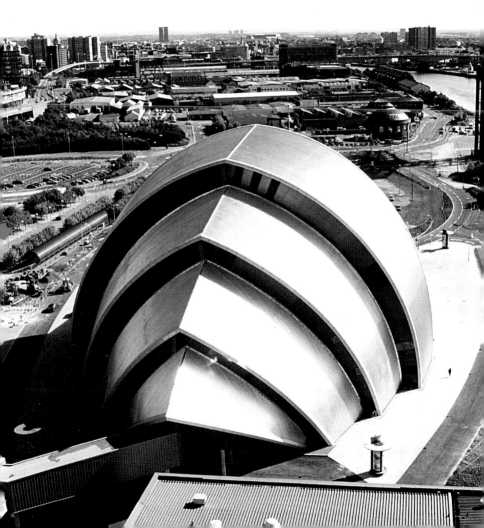

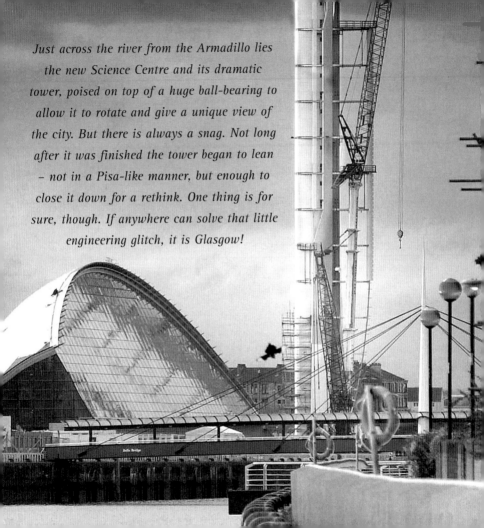

Just across the river from the Armadillo lies
the new Science Centre and its dramatic
tower, poised on top of a huge ball-bearing to
allow it to rotate and give a unique view of
the city. But there is always a snag. Not long
after it was finished the tower began to lean
– not in a Pisa-like manner, but enough to
close it down for a rethink. One thing is for
sure, though. If anywhere can solve that little
engineering glitch, it is Glasgow!